PastryParis

In Paris, Everything Looks Like Dessert

..

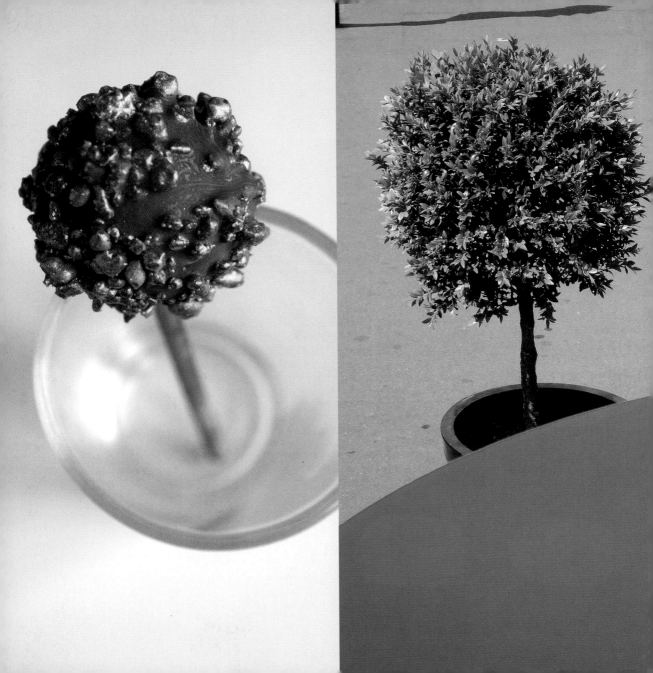

PastryParis

In Paris, Everything Looks Like Dessert

........................

by **Susan Hochbaum**

THE LITTLE BOOKROOM
New York

For J. and for J.

Photographs ©2011 Susan Hochbaum | Text ©2011 Susan Hochbaum | Design ©2011 Susan Hochbaum

Library of Congress Cataloging-in-Publication Data

Hochbaum, Susan.

Pastry Paris: in Paris, everything looks like dessert/by Susan Hochbaum; photographs by Susan Hochbaum.

p. cm.

ISBN 978-1-892145-94-9 (alk. paper)

1. Pastry—France—Paris—Pictorial works. 2. Desserts—France—Paris—Pictorial works.
3. Cooking, French—Pictorial works. 4. Paris (France)—Pictorial works.
5. City and town life—France—Paris—Pictorial works. 6. Street life—France—Paris—Pictorial works.
7. Paris (France—Social life and customs—Pictorial works.
8. Paris (France)—Buildings, structures, etc.—Pictorial works. 9. Bakeries—France—Paris—Guidebooks.
I.Title.

TX773.H59 2011

641.8'650944361—dc22

2011012289

Published by The Little Bookroom | 435 Hudson St., Suite 300 | New York NY 10014
www.littlebookroom.com | editorial@littlebookroom.com

10 9 8 7 6 5 4 3 2 1

It's hard not to love a city with a pâtisserie on nearly every block, where pastries are sold all day long to people who never get fat.

I came to Paris middle-aged, divorced, and newly in love. Granting myself a sabbatical and renting out my suburban home, I moved with my beau to this romantic city for a year of living shamelessly.

Abandoning restraint, and with the appetite of a teenager, I found my muse in butter, cream, and sugar, shaped into sweet sculptures that rival the ones in the city's museums.

I see pastries everywhere, and not just in the pâtisseries. The dome of Sacré-Coeur, gas caps on the sidewalks, topiary in the Place des Vosges...

In Paris, everything looks like dessert.

BOULANGERIE PATISSERIE

Pains de Régime -- Spécialité de Croissants

Graines & Farines

Teleph. 9 B.C. Melun 6138

Livraison à Domicile

Ch. MILLET

SIVRY-COURTRY (Seine-et-Marne)

M _____ Doit

Le _____ 19

Contents

"The fine arts are five in number, namely:
painting, sculpture, poetry, music, and architecture,
the principal branch of the latter
being pastry."

Antonin Carême (1783-1833)

Classics

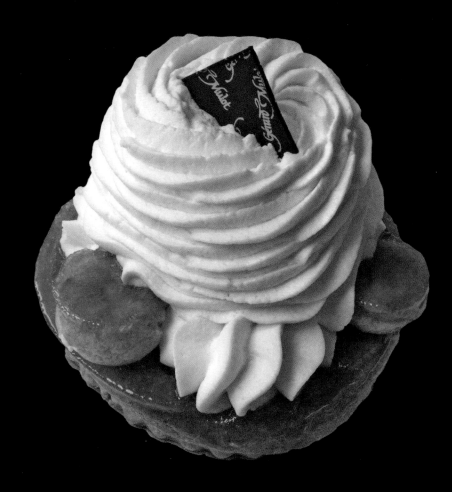

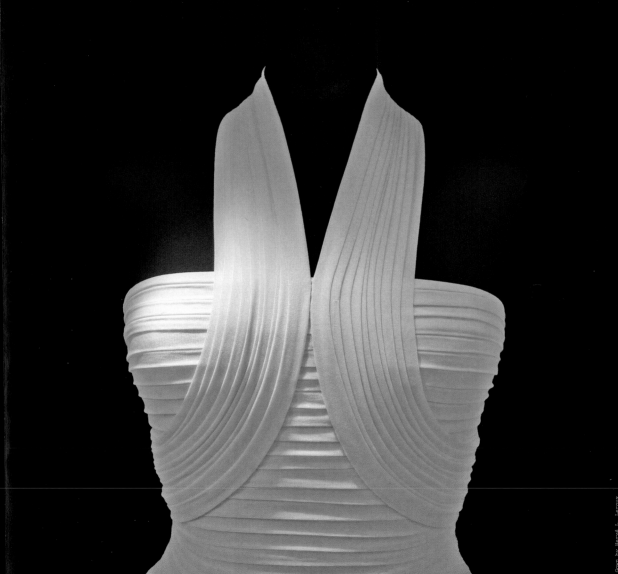

Classics

Talk to a Parisian about dessert and you'll often hear stories of grandmothers, Sunday family lunches, holiday gatherings, and after-school snacks. Some of these classic French desserts have been around since the eighteenth century, when cookbooks became popular and recipes could be spread beyond the royal households. Many of today's versions of these classics are lighter and fluffier than their ancestors, but others have changed very little (tart crusts, for one, are not much different than they were in the Middle Ages). They're the familiar faces in the pâtisserie window, and since you'll find them all over town, they provide the ideal material for comparative taste tests.

St. Honoré | Honoré was the sixth-century Bishop of Amiens in Northern France chosen to be the patron saint of bakers and confectioners.* Legend has it that his childhood nursemaid, while baking bread, had a vision of a mysterious oil being poured on Honoré's head and was convinced it was a sign that he would someday be anointed. Miracles ensued to corroborate her vision and eventually her prediction was realized. The day of his death, May 16, in A.D. 600 is still celebrated by bakers throughout France.

The original Gâteau St. Honoré was invented in the 1840's by M. Chiboust, originator of crème Chiboust, the cream that fills the St. Honoré and countless other French pastries. Today's St. Honoré *individuel* is a ring of filled choux sitting on a round base of puff pastry or shortcrust pastry. Crème Chiboust (or sometimes crème chantilly) is piled high and fills the middle of the ring, and the whole thing is crowned with another filled choux glazed with caramel. It's a dreamy combination of firm and soft pastry, with the slight crunch of caramel, all enveloped in a heavenly cloud of fluffy cream — a truly religious experience.

....................................

*

Religieuse | The Religieuse is a voluptuous pair of cream puffs, one sitting on top of the other, bonded together with buttercream and coated with a glaze of fondant icing. The classic filling flavors are chocolate, vanilla, and coffee, but pastry makers continue to offer new and inventive creations. Ladurée, the legendary tea salon, makes them in exotic varieties like Violette (filled with blackcurrant- and violet-flavored cream) and Rose (rose-petal cream) and recently offered a candy-colored Andy Warhol-inspired series of this classic pastry in passion fruit/coconut/pineapple, raspberry/anise, and caramel/mango.

Choux dough has been used in desserts since the time of Catherine de Medici, but nowhere as evocatively as it is in the Religieuse. Choux means "cabbage" in French and, because of its resemblance to a small cabbage, was the name given to this type of round bun in the eighteenth century. Curiously, this pastry eventually became known as the Religieuse — French for "nun" — because of its resemblance to a nun's habit. One look at the silhouette, however, and you would also have to include the great domes of Paris among the Religieuse's look-alikes — Les Invalides, Sacré-Coeur, the Panthéon, and the interior of the grand Galeries Lafayette department store, its stained glass dome as visually delicious as a box of sugared jellies.

Les Invalides A military complex in the 7th *arrondisement*, housing the Army Museum, Veterans' Hospital and Napoleon's burial ground.

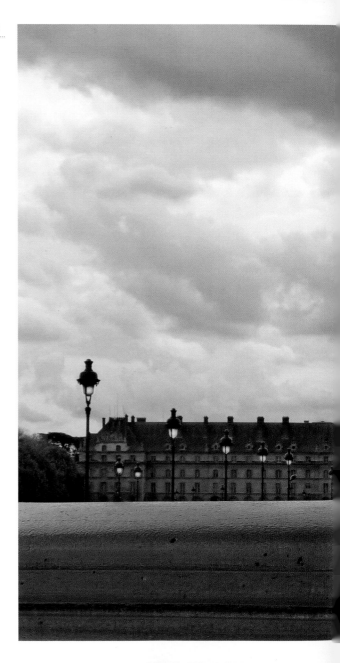

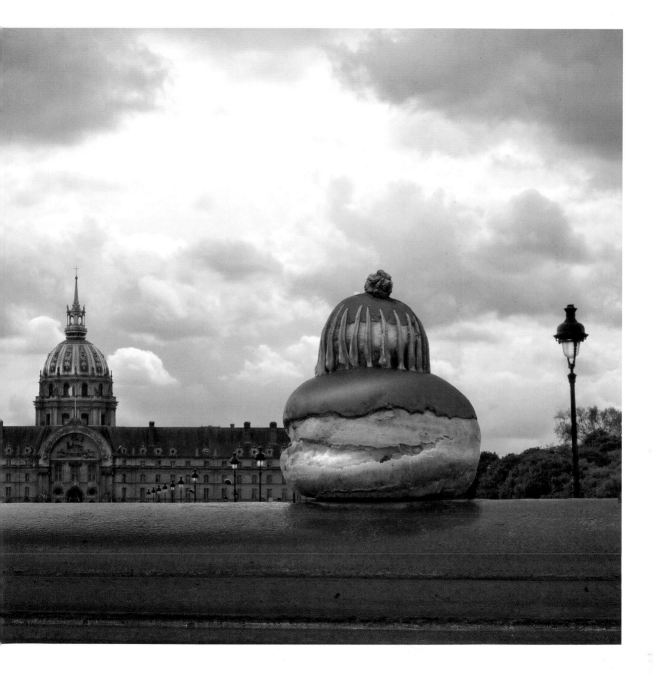

Métro Station, Place d'Italie

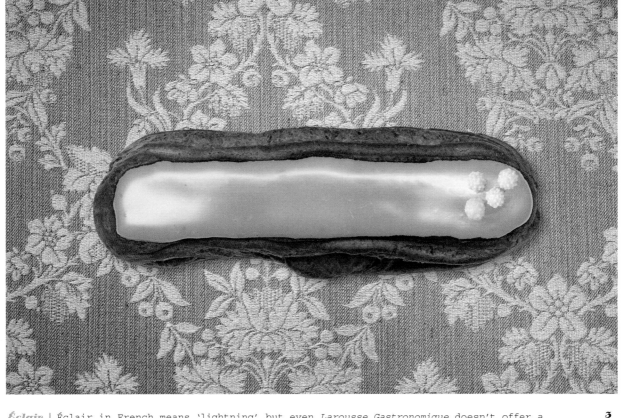

Éclair | Éclair in French means 'lightning' but even *Larousse Gastronomique* doesn't offer a convincing explanation for the connection. Their best guess is that it refers to the glint of light that bounces off the slick coating of icing.

Éclairs are made by stuffing a hollow tube of choux pastry with crème pâtisserie, then applying a glaze of fondant icing. They're found in every pâtisserie window in Paris and range from the basic chocolate and coffee varieties to the wild and exotic imaginings of the pâtissiers of the premier hotel restaurants.

3

The best-known and most prolific supply can be found in the pastry case at Fauchon at the Place de la Madeleine. More dolled-up than your average éclair, specimens there are decorated in stripes, dots, animal prints, and shocking neon colors; adorned with flowers; and most famously, printed with the eyes of the Mona Lisa, on the chocolate-almond éclair "Madame Joconde." Recently for the back-to-school season, Executive Chef Christophe Adam created an éclair homage to the hotdog (*chien chaud*) — the first éclair to be eaten either hot or cold — stuffed with caramel and raspberry. For the gastronomically fearless, he offers a special adventure on Valentine's Day — a marriage of foie gras and strawberry.

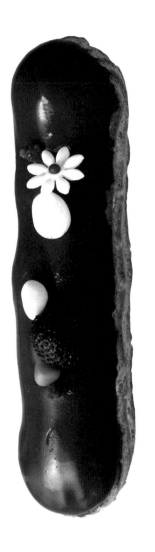

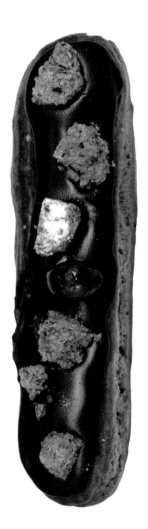

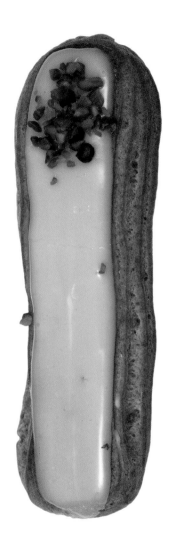

| **_Fig. 1_** | Strawberry | **_Fig. 2_** | Hazelnut | **_Fig. 3_** | Pistachio |

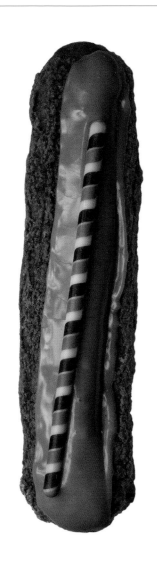

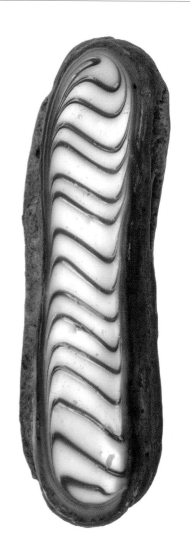

| **Fig. 4** | Mocha | | **Fig. 5** | Blueberry | | **Fig. 6** | Caramel |

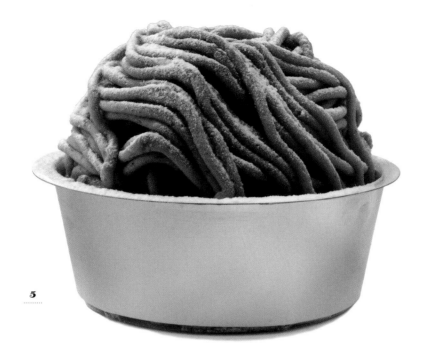

5

Mont Blanc | Technically speaking, the great Mont Blanc is the tallest mountain in the Alps, sitting on the border of Italy and France. For pastry devotees, however, there's only one Mont Blanc and that's the one made of chestnut puree, meringue, and crème chantilly.

The Mont Blanc was first invented by the Italians in the fifteenth century, though by 1620 the French had taken credit for it. In 1903 an Austrian confectioner, Antoine Rumpelmeyer, opened Angelina, a belle époque *salon de thé* decked out in frescoes and gilded mirrors, and became famous for his snow-capped (powdered sugar) Mont Blanc. The café is located in its original spot across from the Tuileries, so you can take your five o'clock tea in the same spot where Coco Chanel and Marcel Proust took theirs.

At Jean-Paul Hévin, the spaghetti-topped Mont Blanc is only made on Fridays and Saturdays — order it in advance so you won't have your heart broken when you arrive and they're sold out.

The Palais Garnier, commonly known as the Paris Opéra, is an opulent Neo-Baroque, 2,200-seat opera house on the Place de l'Opéra. It was the primary home of the Paris Opéra from 1875 until 1989, when the new opera house was built in the Bastille. The central chandelier weighs over six tons.

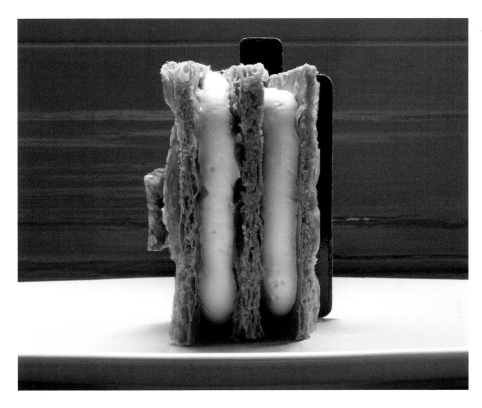

Mille-feuille | La Grande Epicerie at Bon Marché offers a variation on the horizontal mille-feuille by turning it on its side to become a vertical wall of air, sugar, and cream. The party-size ones are ten-inch squares, but they're also available for individual consumption in a satisfying single-serving size.

Mille-feuille | This sublime pastry is commonly called "Napoleon" in America, but the general consensus is that the dessert had nothing to do with the famous Emperor. It's more likely a corruption of the word *napolitain*, meaning "in the style of Naples," and is based on their tradition of making tall, multitiered architectural confections using stripes of alternating textures, colors, and tastes.*

In French, mille-feuille means "a thousand leaves." The mille-feuille is made of layers of crisp and delicate puff pastry with interleaving layers of crème pâtisserie or crème chantilly, and sometimes raspberry jam. They're either iced with white fondant icing decorated with spiderweb lines of chocolate or they're dusted with powdered sugar. For maximum pleasure they should be eaten within four hours of preparation — the airy pastry must shatter easily under your teeth. In Paris the best pâtisseries run out of them by noon on weekends.

Baba au Rhum | The oldest pâtisserie in Paris has been at the same spot on rue Montorgueil since 1730. When King Stanislas Leszczyński of Poland came to France with his daughter in 1725 (she married Louis XV), they brought with them their pastry chef (who wouldn't?), who was both the founder of the pâtisserie and the originator of the French baba. Some say the cake was named after Ali Baba, the hero of The Thousand and One Arabian Nights, a favorite story of the king's.

Pâtissier Nicolas Stohrer, according to most accounts, was responsible for turning the Polish babka that the king found too dry, into the boozy cake we know today, by basting it in Malaga wine and adding saffron, custard, and raisins. Nearly one hundred years later, a descendant of the original Stohrer modified the recipe and created the current baba au rhum, a rum-soaked yeasty cake loaded with raisins, that's still served at the Stohrer shop today. At pâtisserie Pain de Sucre you can even customize the alcohol content of your baba au rhum with a bonus pipette of rum. Like its alcoholic relative the savarin, the baba au rhum is a dessert for grown-ups.

*

Sacré-Coeur sits at the top of butte Montmartre, the highest point in Paris, and offers spectacular views of the city.

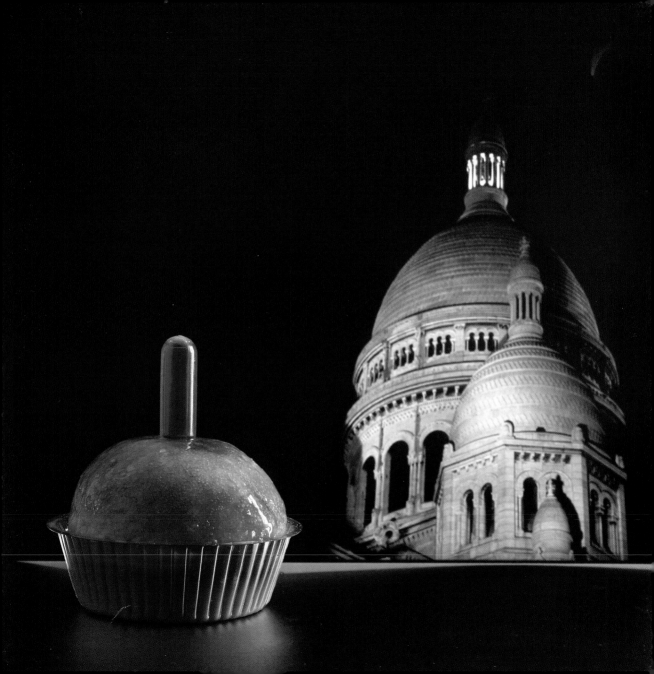

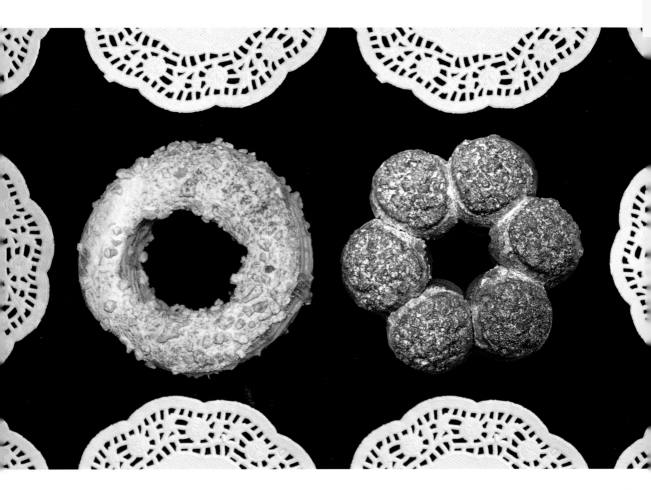

Paris-Brest | The Paris-Brest was named for a grueling 750-mile amateur bicycling race between Paris and Brest that was first run in 1891, and is still run today. Legend has it that an enterprising baker with a shop along the route redesigned the traditional éclair into the shape of a bicycle wheel on the occasion of the first running of the race, and in honor of the committed riders. (The sight of mobs of hungry spectators eager for a snack was likely not lost on him either.)

The dessert is a caramel-colored choux pastry ring sliced in half horizontally, then filled with hazelnut crème pâtisserie and topped with toasted almonds and delicately crunchy sugar crystals (like the crunch of bicycle tires on pavement?). Loaded with calories, the Paris-Brest has become the breakfast of choice among carbo-hungry cyclists, but works equally well for a sedentary lounge in a sidewalk café.

Musée Carnavalet in the Marais is devoted
to the history of the city of Paris and
is housed in two neighboring sixteenth-
century mansions.

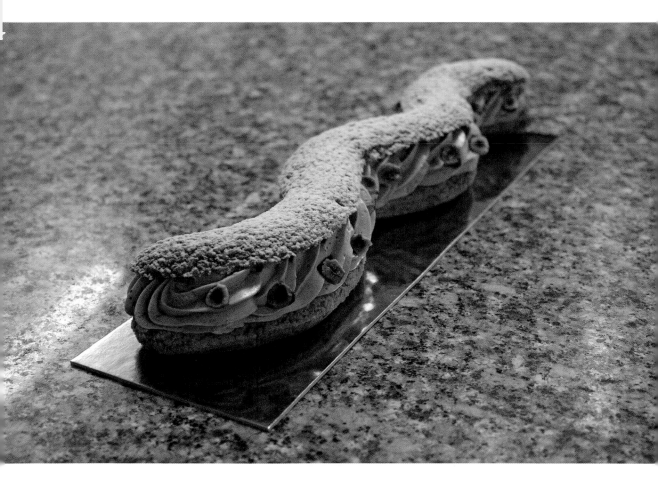

The Paris-Brest is currently making a comeback in the gastro-bistros of Paris. Often you can find them "to share" where the menu encourages you to leave room. At the Plaza Athénée, Executive Pastry Chef Christophe Michalak, 2005 winner of the Coupe du Monde de la Pâtisserie, (World Pastry Cup), has reimagined the Paris-Brest as a reptile.

9

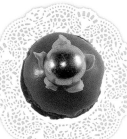 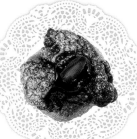 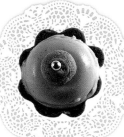 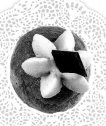

Petits fours | The French seem to delight in all things miniature, from tiny eighteenth-century portraits on snuffboxes to pom-pommed toy poodles. The diminutive desserts called *petits fours* are under-sized versions of classic French creations — decorated cakes, specialty cookies, bite-sized bonbons, and sugared fruits. The most common of the teeny-weeny tidbits are the *petits fours glacés*, the iced and decorated cakes found in a seemingly infinite variety of shapes, flavors, and colors. They're generally eaten at the end of a meal with coffee, or as part of a bigger dessert course.

Petit four literally means "small oven." The name dates from the eighteenth century when huge brick ovens were used — large cakes were baked first, then as the oven cooled down, the smaller cakes could be baked at the perfect lower temperature.

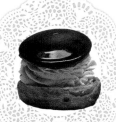 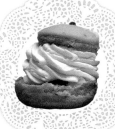 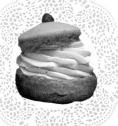 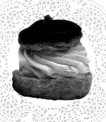

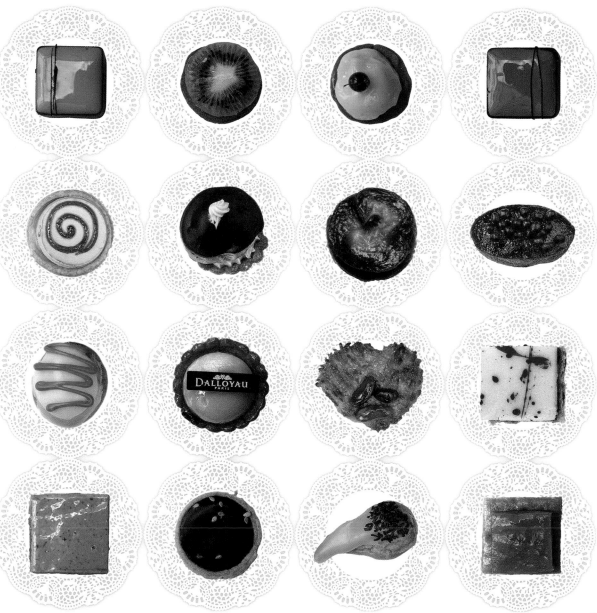

"To create a fine dessert, one has to combine
the skills of a confectioner, a decorator, a painter,
an architect, an ice-cream manufacturer, a sculptor,
and a florist. The splendour of such
creations appeals above all to the eye —
the real gourmand admires them without touching them!"

Eugene Briffault (1799-1854)

Inventions

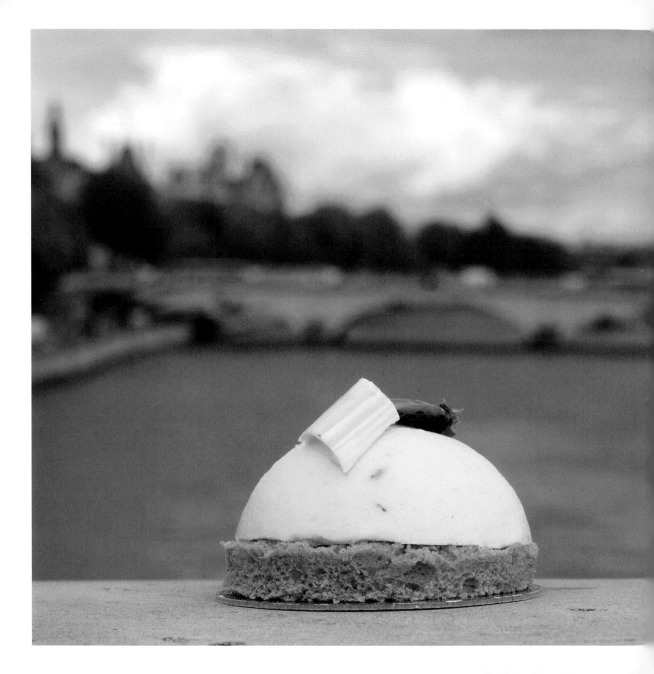

Having mastered the classics, the best pâtissiers, like all great artists, are driven to create something original. Like *haute couturiers*, they offer new collections every season, sometimes concocting audacious flavor combinations (consider the grapefruit/wasabi macaron or the marriage of curried pineapple pulp with cilantro cream) and using color, texture, and composition in offbeat ways. Often taking inspiration from around the globe, exotic ingredients like *yuzu* (a Japanese citrus fruit), *matcha* (Japanese green tea), and lychee have become more common.

None of this would have been possible if it weren't for Gaston Lenôtre, considered the inventor of modern pastry. In the 1960's he began a revolution in the pastry world by reinterpreting the classics — he reduced the cream, butter, and sugar content to make pastries that were more suitable and appealing to the modern palate. You can thank him for the whimsy and imagination seen in pâtisserie windows today.

Mousse à la Menthe | A dome of mint-infused mousse sits on a layer of strawberry jam, raspberry coulis and a *biscuit à la cuillère* (ladyfinger).

Pont Neuf looking east to Pont au Change

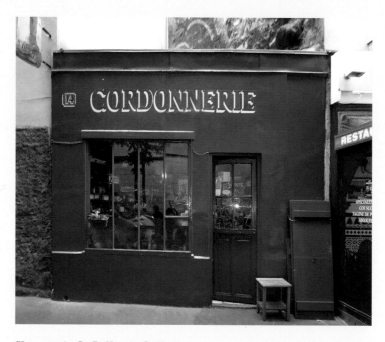

Shoe repair, La Butte aux Cailles

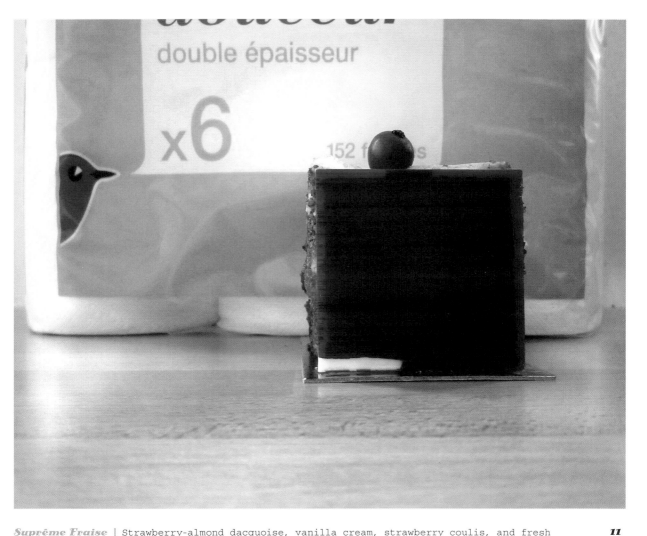

Suprême Fraise | Strawberry-almond dacquoise, vanilla cream, strawberry coulis, and fresh strawberries are housed inside the painted white chocolate walls.

11
............

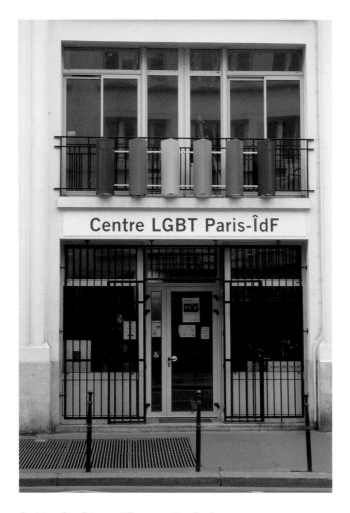

Lesbian Gay Bisexual Transgender Center

Bonbons Maquillage | Literally "makeup candy," these are miniature chocolates infused with flavored ganache, keyed to the spectrum of rainbow colors applied to their surfaces. Like the eye shadow counter at Shu Uemura.

Yuzu Cube | *Yuzu* cream and *yuzu* mousse sit on a chocolate cookie, encased in a praline cookie wall.

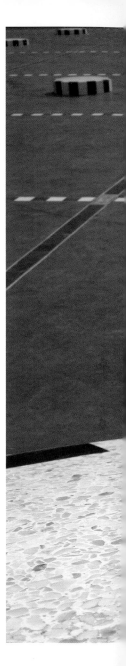

Pistache Fraise | Pistachio genoise and strawberry coulis are encased in a thin coating of marzipan and encircled by wafers of white chocolate.

Palais-Royal Daniel Buren's installation of black-and-white columns in the courtyard of the Palais-Royal in 1986 sparked a fierce controversy around the mix of modern art and historic architecture.

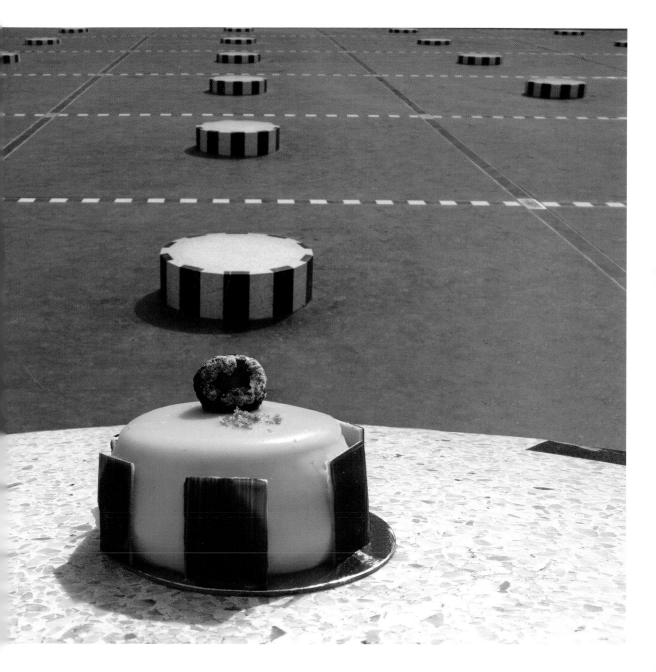

Cupcake à la Vanille | Bite into the iced vanilla cupcake to uncover the secret twin raspberry.

Celia | A hazelnut cake is topped with swirls of creamy praline and covered with a sheet of milk chocolate.

Passionata | Passion fruit and chocolate are layered in this dessert of coconut shortbread, passion fruit cream, coconut cream, and milk chocolate.

Gâteau Caramel | Cocoa-dusted choco-
late mousse provides the architecture
for pools of caramel, salted caramel
and dark chocolate.

Le Marais One of the oldest sections
of Paris is now a neighborhood of quirky
boutiques, museums, Jewish shops, and
gay bars.

Le Royale | The specialty of Arnaud Delmontel, the Royale is filled with chocolate-flavored chantilly and crunchy praline, and sits on an almond cake base. 19

Canal Saint-Martin Built by Napoleon
in 1802 to supply fresh water to the city,
it's now a tourist destination where
you can watch barges navigate the locks
and bridges.

47

Swan | A cone of chocolate mousse and flowing caramel are balanced on a pecan biscuit base.

Place des Vosges in the Marais, is
the oldest planned square in Paris.
It's lined with red brick houses and
an arcade of cafés and galleries.

Muguet | May Day is an important holiday in Paris, with many businesses closed and ordinary citizens, children, and members of the Communist Party selling small bouquets of *muguet* (lily of the valley) on the city's sidewalks. While many bakeries in Paris offer delicate marzipan versions of the flowers,* Gérard Mulot approaches the tender *muguet* with audacity — lollipops of pistachio and vanilla macarons set in a dark chocolate flowerpot are zany and yummy.

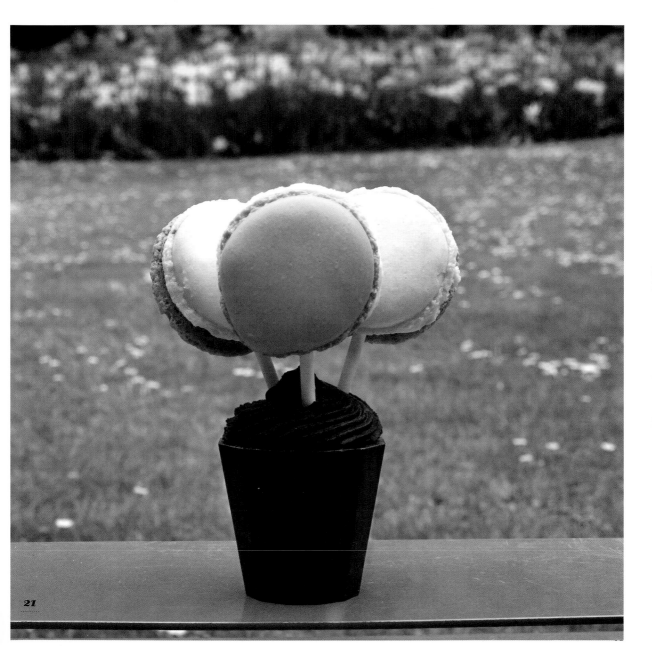

Feuille D'Automne | Created by Gaston Lenôtre,
the Feuille d'Automne (Autumn Leaf) is a light
chocolate cake made of meringue, mousse, and
chocolate ganache, covered in dark chocolate
and topped with thin, frilly chocolate leaves.

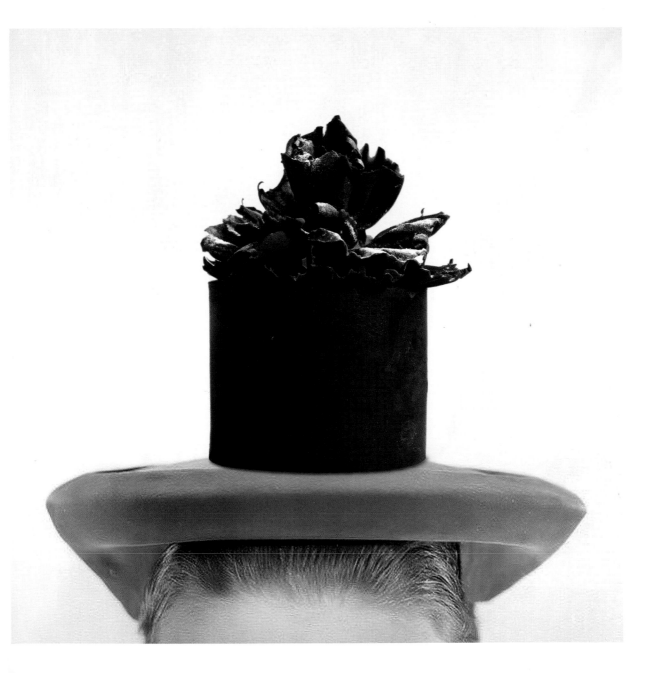

Alhambra | Meringue, coconut, and whipped cream are held in place by a white chocolate s

Red Power | Topped with chantilly flavored with lychee, this cluster of petals by Christophe Michalak is made of strawberry *bavaroise* and strawberry confit. The financier at the base is filled with more strawberry confit and fresh strawberries.

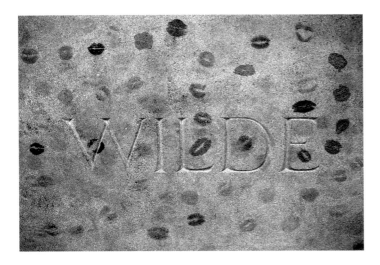

Grave of Oscar Wilde Adoring fans come to Wilde's tombstone in Père Lachaise Cemetery to pay tribute and plant kisses.

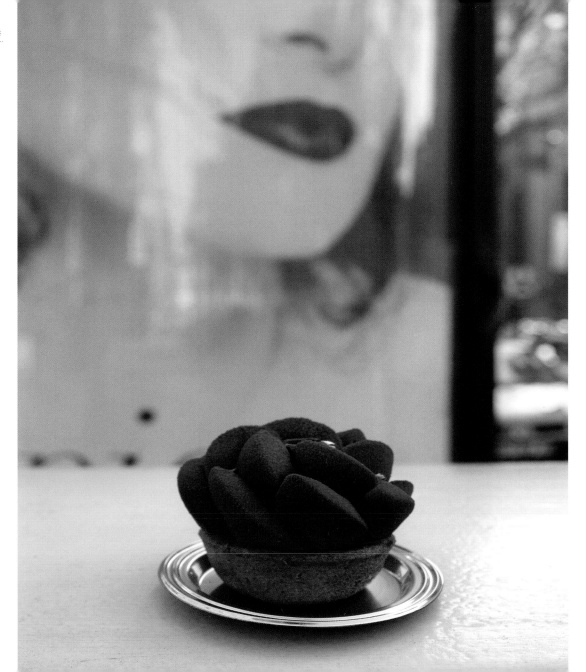

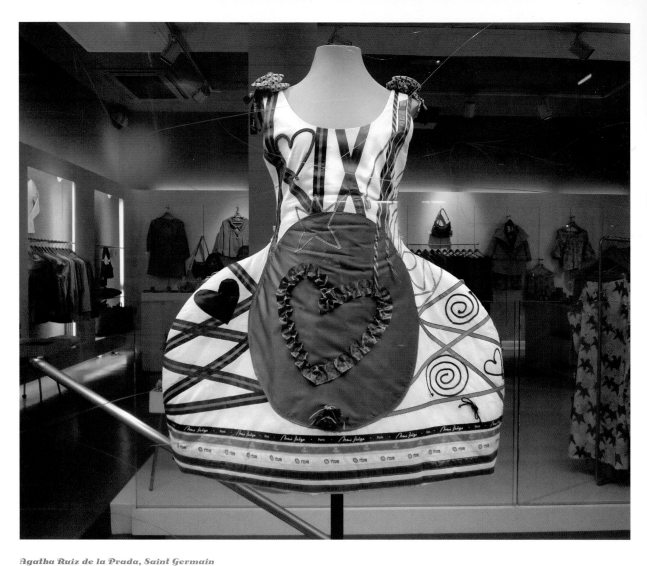

Agatha Ruiz de la Prada, Saint Germain

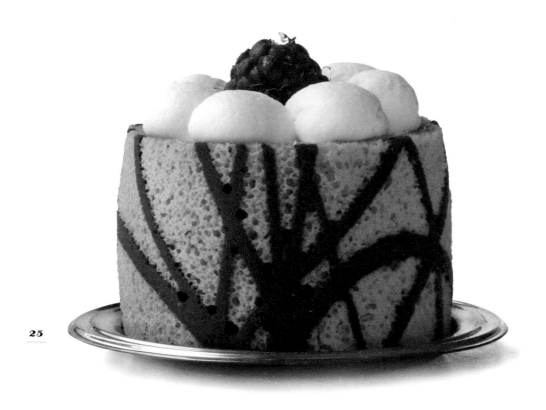

Everest | The snow on this Everest is chantilly, and caps a soft pistachio cake filled with berry coulis, laced with vanilla and bourbon.

Framboisier | Even the frozen foods of Paris are inspired. Picard, a chain of frozen-food emporiums, provides tasty, healthful, and handsomely-packaged foods for harried Parisians. The *framboisier* is a light, sugar syrup-moistened cake split in half and filled with raspberries and pastry cream.

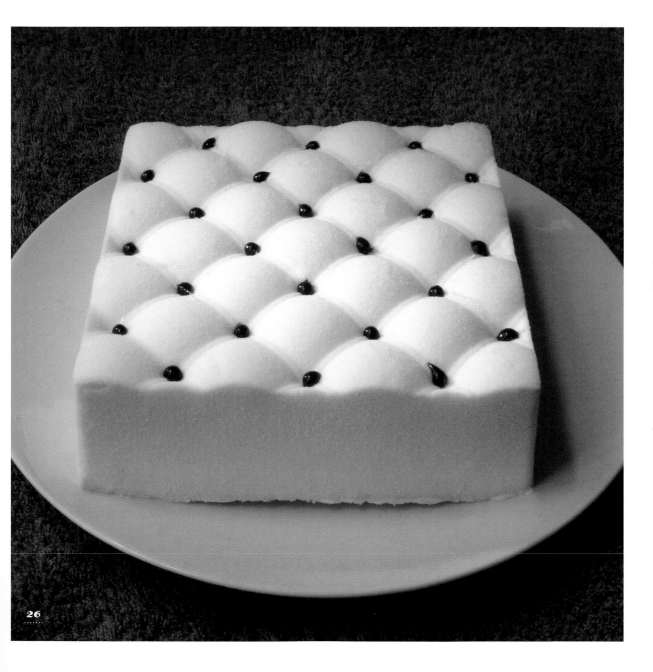

Wardrobe, Louvre French decorator André Groult created this wardrobe for the room of "Madame l'Ambassade" at the 1925 International Exposition of Decorative Arts, where the term "Art Deco" was coined.

Fig. 1	Pomme de Terre

Fig. 2	Pomme de Terre

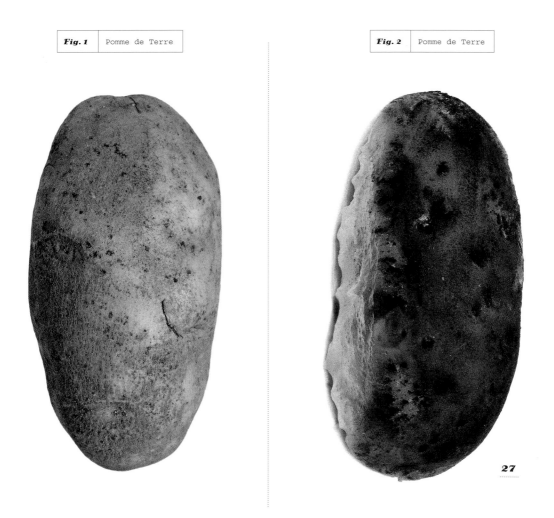

27

Pomme de Terre | A dead-on look-alike for the real thing, this is a marzipan-coated chocolate cake with candied orange peel, nuts, and rum-soaked raisins, garnished with a ganache.

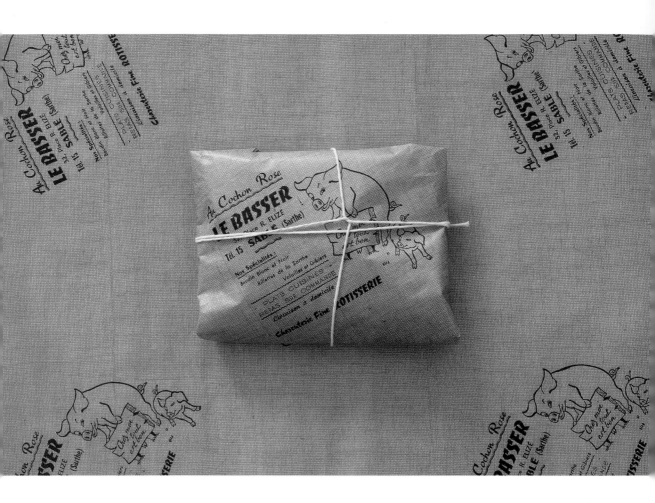

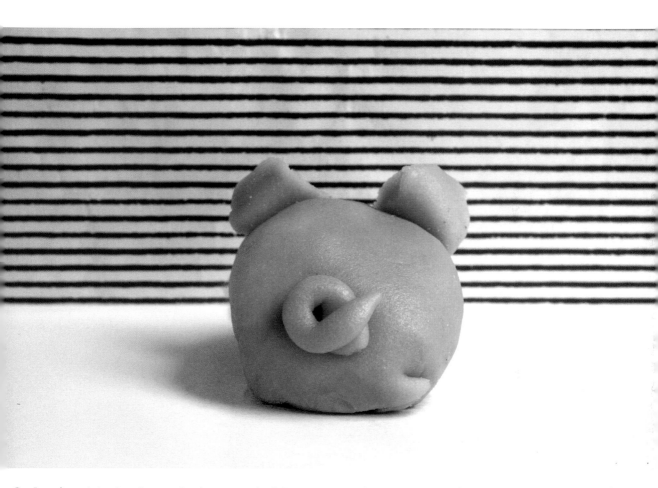

Cochon | A rich chocolate cake is covered with sugary marzipan and shaped into a pig. **28**

Fruitier de Mangue | A film of white chocolate coats a dome of vanilla-flavored chantilly with pieces of fresh mango and is set on a pine-nut/almond cake. Each season brings a new "Fruitier" from chef Philippe Conticini at La Pâtisserie des Rêves.

Place du Trocadéro One of the best views of the Eiffel Tower can be seen from the Place du Trocadéro. It's also the site of the Palais de Chaillot which houses the Naval Museum and the Théâtre National de Chaillot.

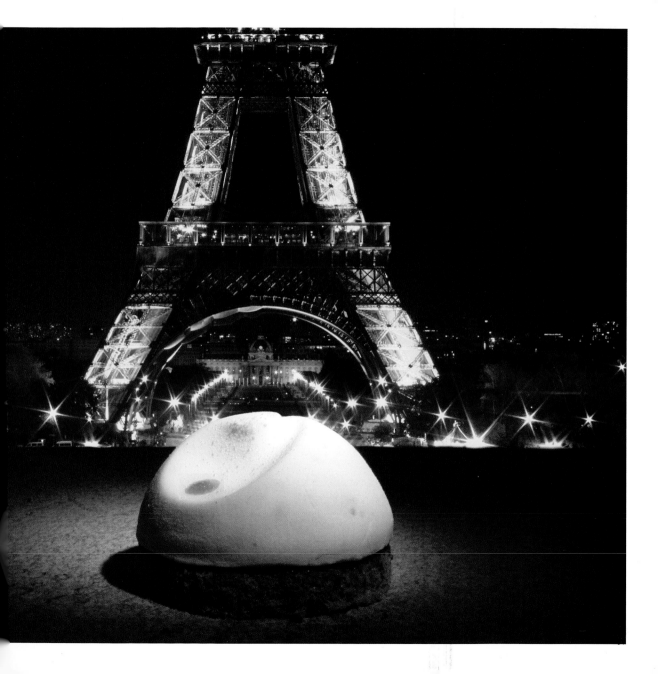

"I compare a pastrycook...to a
distinguished fashion designer, endowed with
perfect taste, who can make charming things
with very little material.
In the same way, out of almost insignificant
scraps of pastry, we have to create pleasing and
graceful things that also tempt the appetite."

Antonin Careme (1783-1833)

Tarts

Tarts

American pies hide their ingredients under top crusts. In France the open tart is the perfect canvas on which to paint with fruit, cream, custards, meringue, and chocolate. Crusts are either pie- or shortcrust pastry, sweet pastry (*pâte sucrée*) or puff pastry; toppings are everything from shiny glazes of lemon custard to rough-cut piles of apples, or slices of pears, figs, apricots, prunes, bananas, peaches, and occasionally the hairy kiwi. They're round, square, or rectangular, sometimes rustic and disorderly, sometimes refined, and often sport exuberant Busby Berkeley-style arrangements of berries, nuts, and other toppings.

Sonia Rykiel | Chocolate maker Christian Constant created this tart in honor of his friend, fashion legend Sonia Rykiel. Collaborators for many years, he created the first chocolate gown for the designer at the yearly Salon du Chocolat, where outfits made of chocolate are the centerpiece of the five-day exhibition. This tart is banana and chocolate, Madame Rykiel's favorite flavor combination.

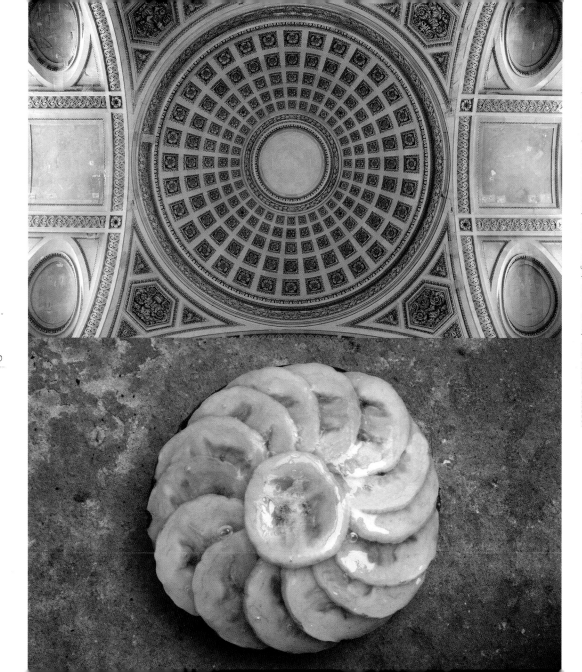

Guerlain, Champs-Elysées

Ritz Paris, Place Vendôme

Tarte au Caramel | A spiral top of chocolate mousse dusted with cocoa covers this tart of salted caramel in a base of *pâte sucrée*.

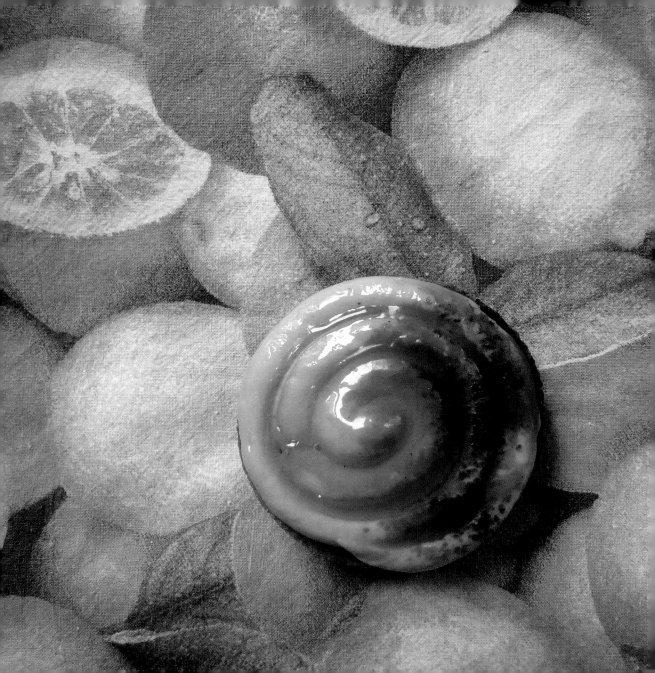

Tarte Mangue et Chocolat | Mango cream tops a chocolate tart.

PLANORBIS

Museum of Natural History This panel is from a display of mollusks in the Gallery of Paleontology and Comparative Anatomy, which houses nearly 1,000 skeletons.

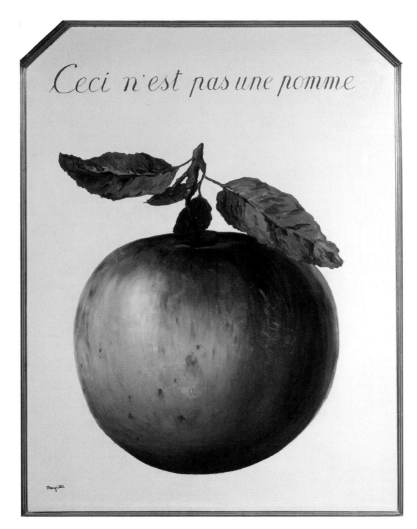

This Is Not an Apple, René Magritte

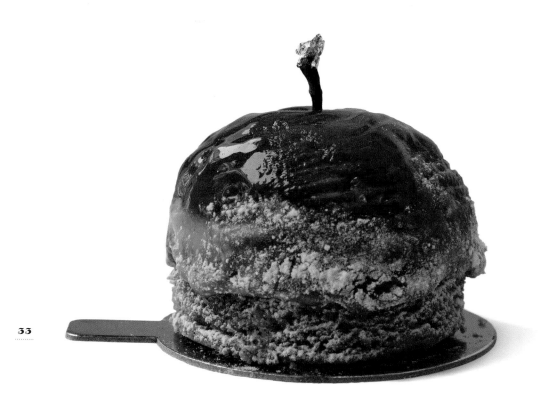

33

Tarte Tatin | The most famous of all French tarts is the Tarte Tatin. It's an upside-down apple tart that began as a happy accident in the Lamotte-Beuvron region late in the nineteenth century. Made of apples cooked in butter, caramelized until they're brown and syrupy, sitting on a golden pastry crust, it's best when served warm with a dollop of cold crème fraîche.

The Tatin sisters, owners of a popular inn and restaurant in the hunting region of central France, were known for their deep-dish apple pie cooked with apples on the bottom and a crust on top. Legend has it that one evening the pie was dropped as it came out of the oven and the crust badly cracked. In a flash of genius, one of the sisters turned the unsightly pie upside down onto a plate and the Tarte Tatin was born. The new recipe eventually found its way into the restaurants of Paris; Maxim's was the first to serve it, and it's still one of the house specialties.

Over the years variations on the official Tarte Tatin recipe developed and spread, a heresy that greatly disturbed the citizens of Lamotte-Beuvron. A "Brotherhood Gourmande" was formed to defend their beloved pie and to protect and promote its consumption.

Despite the efforts of the Brotherhood, pâtissiers still play with the form of the Tarte Tatin — the faux apple served at Blé Sucré is a Tarte Tatin in disguise.

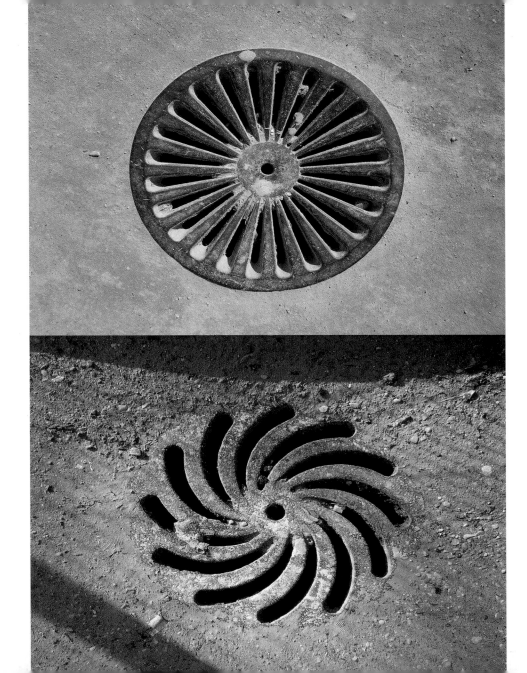

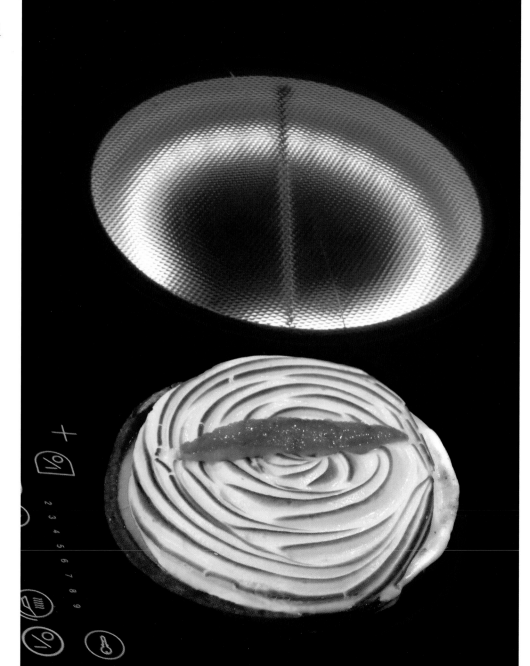

Tarte au Citron Meringuée | There are two schools of thought on the Tarte au citron – meringue topping: oui or non? Traditionally, a browned swirl of meringue tops the tart, but some contemporary chefs prefer a topping of lemon jelly that provides a slick mirrored finish over the sour lemon cream.

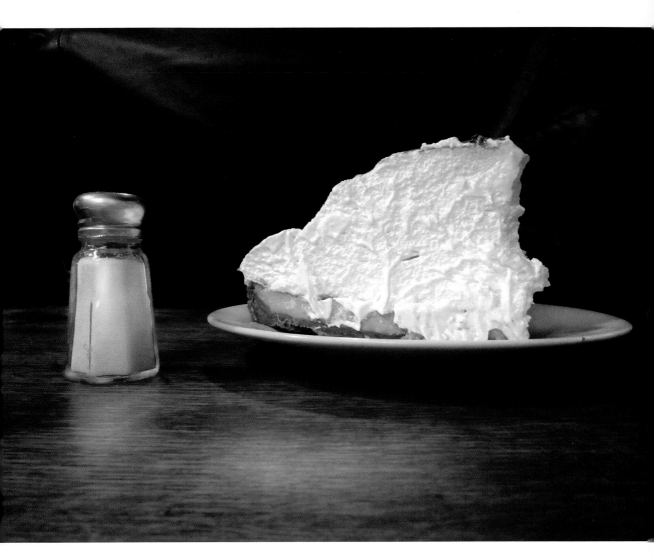

Tarte au Citron Meringuée

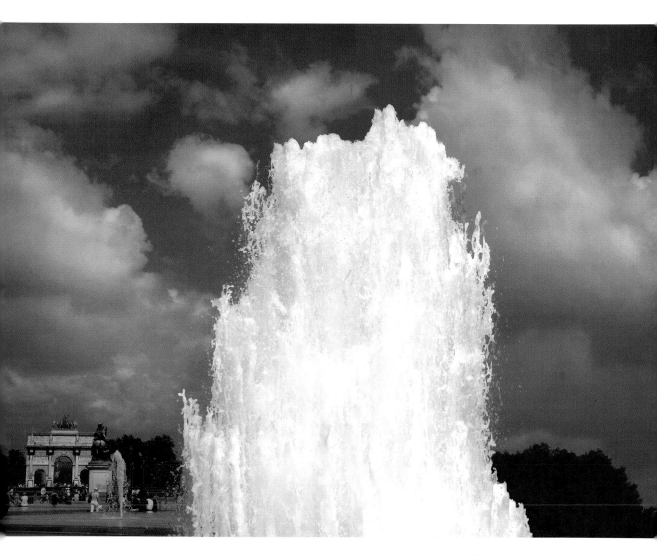

Fountain, Pyramide du Louvre

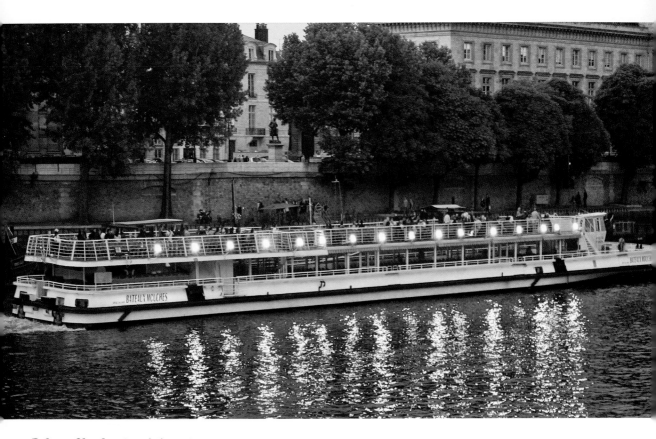

Bateaux Mouches One of the most
relaxing ways to see Paris is from the
glass-covered decks of the longboats
that cruise the Seine.

Tarte au Citron Meringuée | Christophe Michalak's interpretation of the classic *tarte* with a shortbread base, a layer of lemon curd, soft meringue peaks, lemon gelée, and lemon and lime confit.

36

37

Passion Fruit Tarte | Pre-shaped *pâte sucrée* tart wedges are baked separately, lined with a little *crème d'amande*, and filled — in this case with passion fruit cream. The fillings change seasonally at Hugo & Victor Pâtisserie.

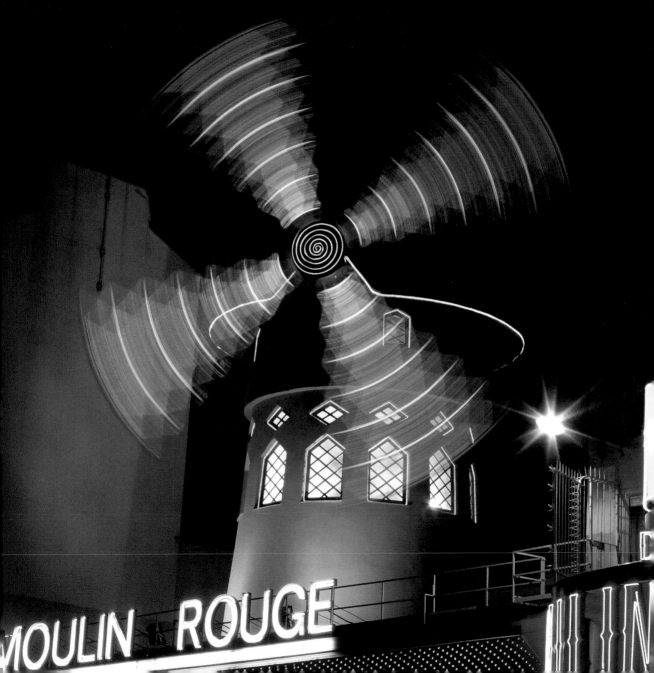

"If you are not feeling well,
if you have not slept, chocolate will revive you.
But you have no chocolate!
I think of that again and again!
My dear, how will you ever manage?"

Marie, Marquise de Sévigné, seventeenth century

Macarons
and
Meringues

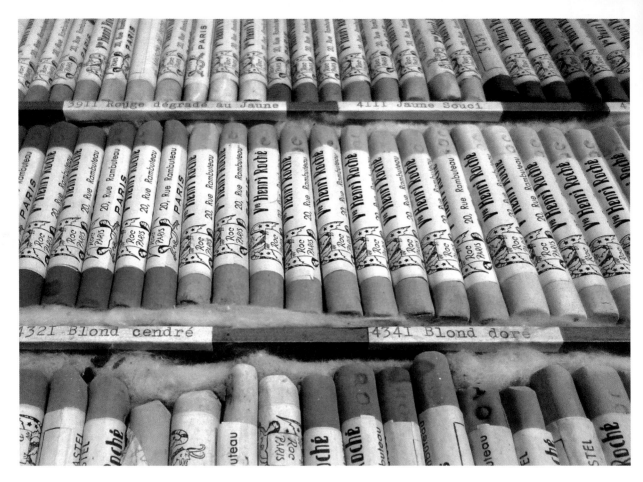

Musée d'Orsay The handmade pastels
by Henri Roché were favorites among the
Impressionists. Roché collaborated with
Degas, Whistler, and others to develop the
formulation and palette of the pastels.

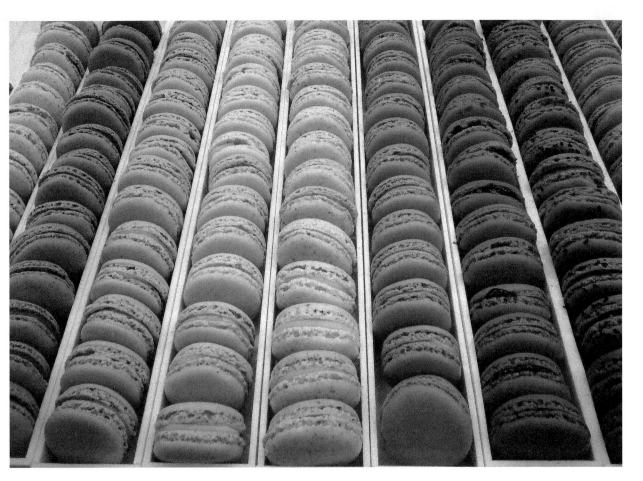

Macarons | The first macarons were simple almond meringue cookies without fillings. Various sources attribute them to Catherine de Medici's pastry chef who brought the Italian recipe to France at the time of her marriage to Henry II. Others say that Italian monks created them and modeled them after their own belly buttons. Ladurée claims that today's double-decker macaron was the brainchild of Pierre Desfontaines at its *salon de thé* at the beginning of the twentieth century.

38

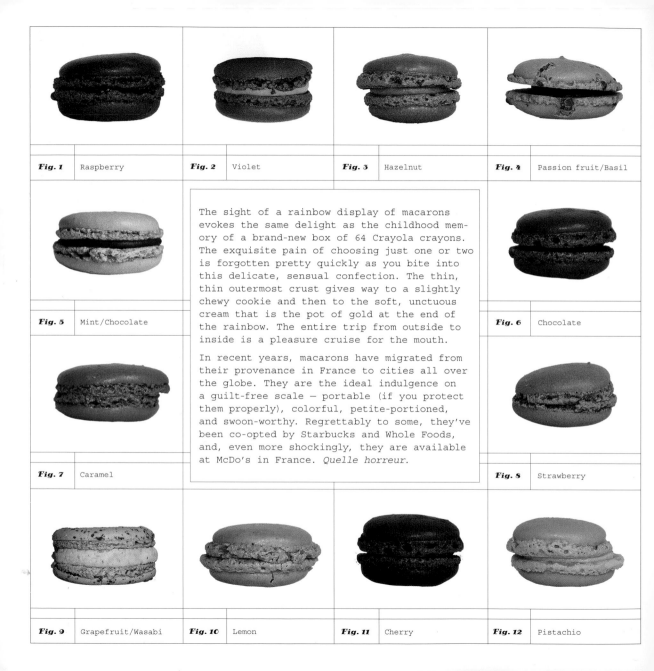

Fig. 1 Raspberry

Fig. 2 Violet

Fig. 3 Hazelnut

Fig. 4 Passion fruit/Basil

Fig. 5 Mint/Chocolate

Fig. 6 Chocolate

Fig. 7 Caramel

Fig. 8 Strawberry

Fig. 9 Grapefruit/Wasabi

Fig. 10 Lemon

Fig. 11 Cherry

Fig. 12 Pistachio

The sight of a rainbow display of macarons evokes the same delight as the childhood memory of a brand-new box of 64 Crayola crayons. The exquisite pain of choosing just one or two is forgotten pretty quickly as you bite into this delicate, sensual confection. The thin, thin outermost crust gives way to a slightly chewy cookie and then to the soft, unctuous cream that is the pot of gold at the end of the rainbow. The entire trip from outside to inside is a pleasure cruise for the mouth.

In recent years, macarons have migrated from their provenance in France to cities all over the globe. They are the ideal indulgence on a guilt-free scale — portable (if you protect them properly), colorful, petite-portioned, and swoon-worthy. Regrettably to some, they've been co-opted by Starbucks and Whole Foods, and, even more shockingly, they are available at McDo's in France. *Quelle horreur.*

Fig. 13 Chestnut/Green Tea	*Fig. 14* Yuzu	*Fig. 15* Cherry/Pistachio	*Fig. 16* Lime/Verbena
Fig. 17 Olive Oil/Vanilla	*Fig. 18* Raspberry/Chocolate	*Fig. 19* Chocolate/Coriander	*Fig. 20* Passion fruit/Chocolate
Fig. 21 Vanilla	*Fig. 22* Cherry-Vanilla-Chocolate	*Fig. 23* Blackberry	*Fig. 24* Banana/Ginger
Fig. 25 Pear/Caramel	*Fig. 26* Rose	*Fig. 27* Cassis	*Fig. 28* Orange/Ginger

39

Macaron à l'Ancienne | Two macarons are packed with almonds, filled with chocolate ganache, and dusted with powdered sugar and powdered cocoa.

92

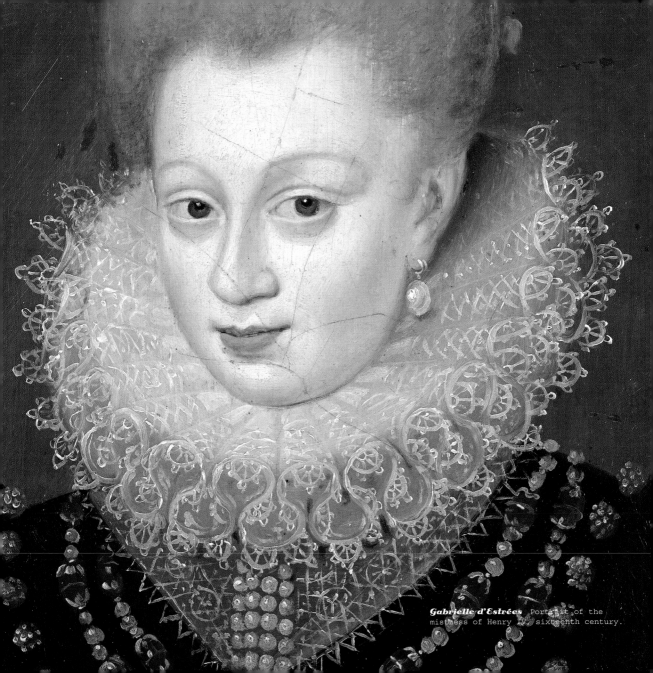

Gabrielle d'Estrées Portrait of the mistress of Henry IV, sixteenth century.

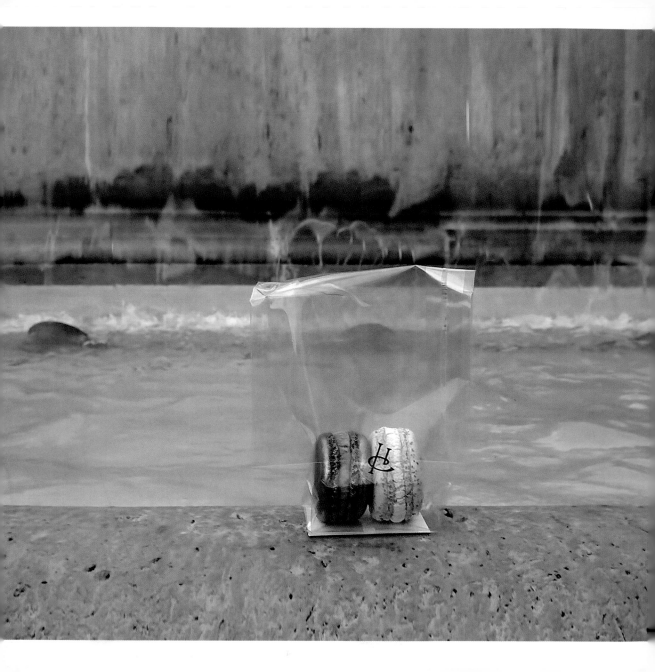

Fountain Saint-Sulpice is located in the
Place Saint-Sulpice, in front of the church
of the same name, the second-largest in
Paris after Notre Dame.

Meringues

When they're made perfectly, they've got a sweet chewy heart, but these dry, feather-weight cookies generally tend to be a love-them-or-hate-them affair. The ingredients are simple: whipped egg whites and sugar, sometimes flavored with vanilla, chocolate, or almond extract — but as they're extremely sensitive to humidity, it's not always easy to achieve the perfect crispness. The billowy batter is piped through a pastry bag to create shapes ranging from swirly mounds to kisses, mushrooms, and nests, or shaped with the bowl of a spoon or a spatula into rough loaves in delicate pale colors.

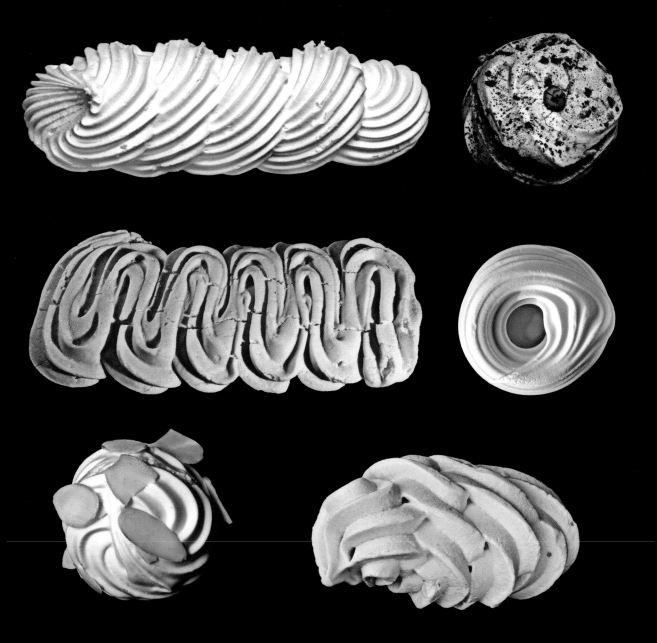

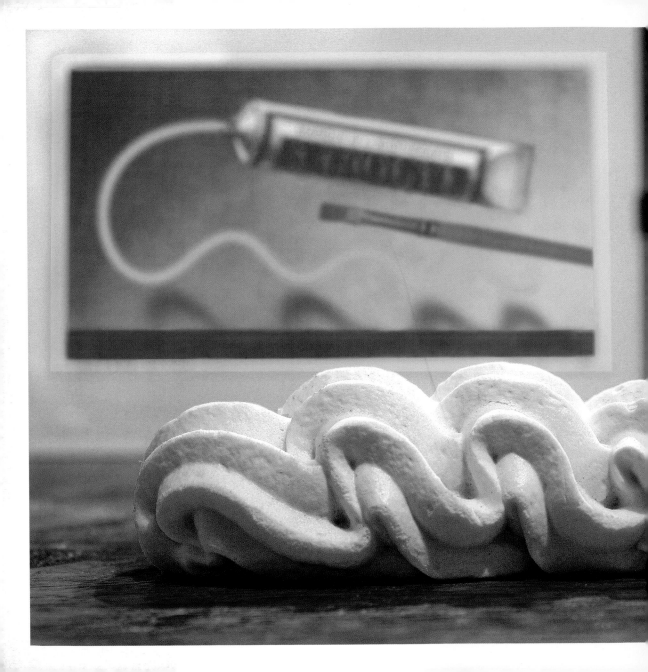

Meringue Amande

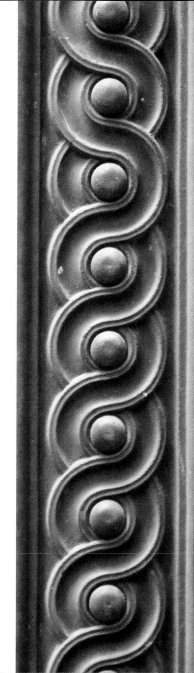

L'Église de la Madeleine Scrolling decorates the door of the neoclassical church, which was commissioned by Napoleon to honor his army.

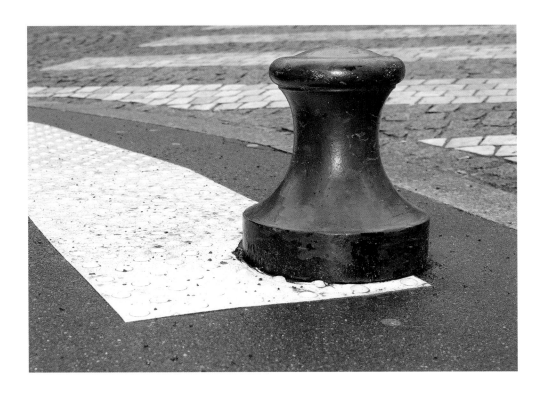

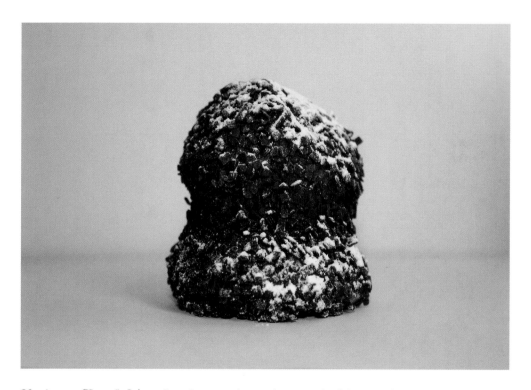

Meringue Chocolat | A chocolate meringue is coated with crunchy chocolate bits and dusted with powdered sugar.

41

Parc de Belleville is located in the
multiethnic neighborhood of Belleville in
the northern part of Paris, now home to
many artists and musicians. It's the
highest park in Paris and has the longest
cascading water fountain in the city.

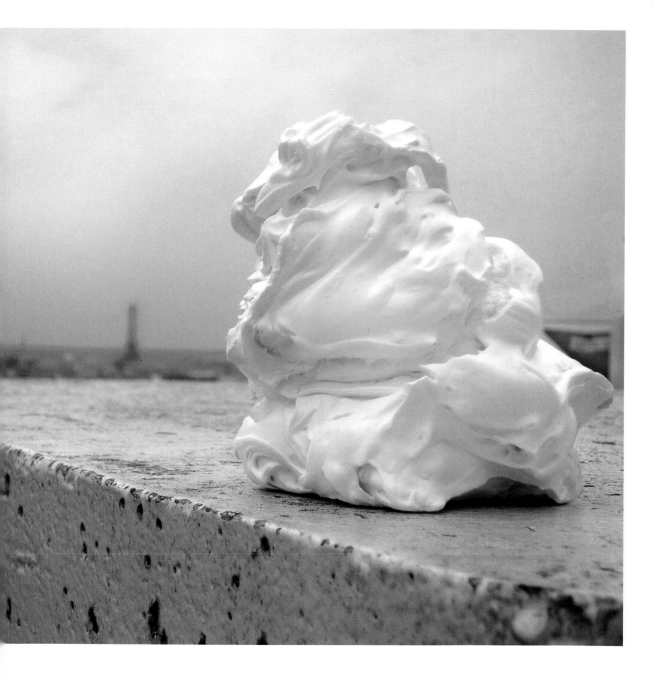

- - - - - - - - - - - -

"I feel the end approaching.
Quick, bring me my dessert..."

Pierrette Brillat-Savarin,
Jean Anthelme Brillat-Savarin's 99-year-old
great-aunt

- - - - - - - - - - - -

Viennoiserie

Viennoiserie

Breakfast in Paris is not about starting the day with a shot of good-for-you protein and a vitamin pill. One of the greatest pleasures in eating *le petit déjeuner* in Paris is the reckless tearing into a buttery croissant while telling yourself you're only doing it in order to experience the local culture.

Viennoiserie refers to the bread-like pastries reserved for the morning, for snacks (*goûters*), and for tea time. Croissants, madeleines, brioche, financiers, *canelés, chausson aux pommes, pain aux raisins*, and *chouquettes* aren't the peacocks of the pastry case. Their rich, buttery, often sweet, sometimes flaky natures are hidden behind simple, mostly geometric exteriors, primarily variations on beige. They're often found at the back of the pâtisserie close to the cash register, and travel well; so you can buy them early and eat them when you're desperate for a treat later in the day, after you've walked enough to gulp them down guiltlessly.

Croissant | If there's a national symbol of France it would have to be the croissant. A virtual match to Napoleon's military head-gear, it's the iconic breakfast item of the land. It's sold in two varieties: *ordinaire* (made with margarine, less expensive), and *croissant au beurre* (the genuine article). *Pain au chocolat* is a croissant filled with choco-late, and along with the *croissant aux amandes* (filled with frangipane, or almond paste, and covered in sliced almonds and powdered sugar) are staples in every *boulangerie/pâtisserie*. Light, buttery, and flaky, a croissant is the perfect way to start a day of indulgence in the city where indulgence never sleeps.

According to culinary mythology, the crois-sant was actually born in Vienna. There's a legend about a baker who created it in honor of a victory over the Turks (its shape mod-eled after the crescent on the Ottoman flag*), and one about Marie Antoinette bringing the recipe with her when she came to marry Louis XVI as a reminder of her happy childhood in Vienna. The more likely story is that a Vien-nese part-time baker who was also an artillery officer and press magnate, brought the Austrian *kipfel* to France. In 1838, August Zang served this crescent-shaped roll at his famous Parisian Boulangerie Viennoise on rue de Richelieu. It wasn't until early in the twentieth century that it was reinterpreted and immortalized in puff pastry by the French.

..

*

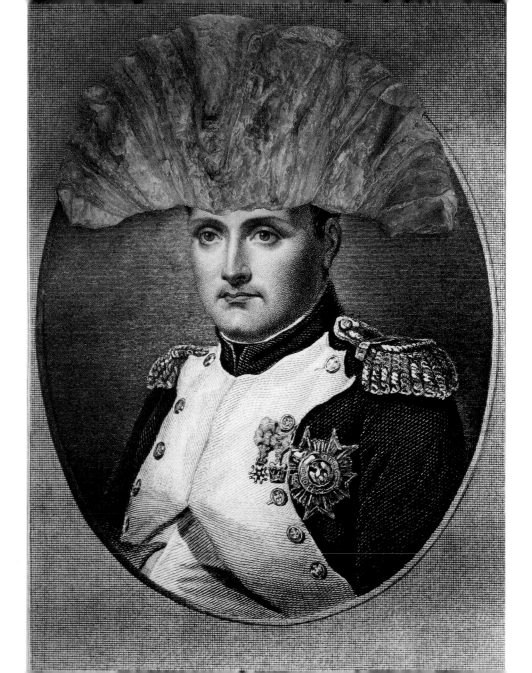

Chouquette | The simplest, purest incarnation of the same *pâte à choux* used for éclairs, Paris-Brest, Religieuse, and profiteroles, the *chouquette* is a puff of air surrounded by a delicate pastry and covered with coarse nuggets of sugar. They're the perfect afternoon snack, just enough to get you from lunch to dinner. The best ones have a crunchy glaze of caramelized sugar on the bottom from where they stuck to the pan, and collapse like a deflated balloon in your mouth. They're sold by weight and since they weigh almost nothing, you can fill a bag easily. The thin paper sacks are always closed the same way, no matter where you buy them: holding the top corners, the bag is spun in the air and the two resulting rabbit ears keep the contents inside the bag for as long as you can hold out before ripping it open.

Jardin Albert Kahn In 1909, banker and philanthropist Albert Kahn sent photographers all over the world to document little-known cultures. On the grounds of the museum in Boulogne-Billancourt is an extensive mosaic of gardens, including a traditional Japanese garden.

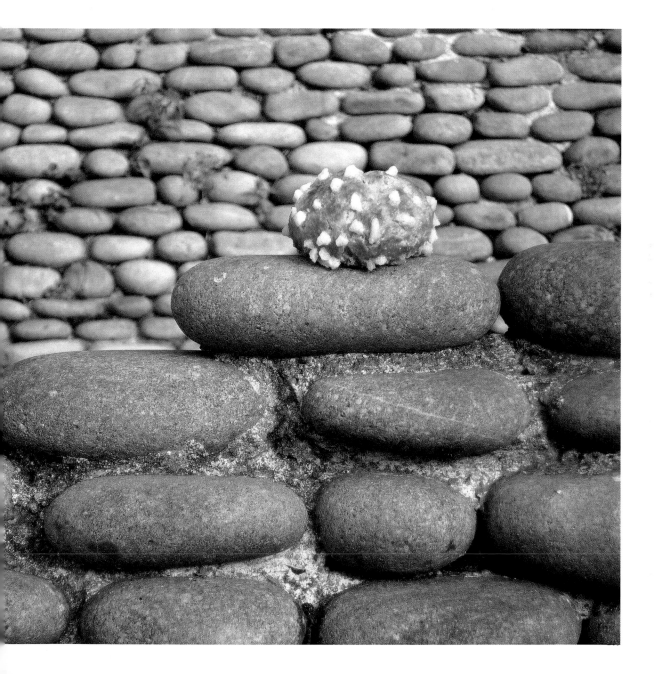

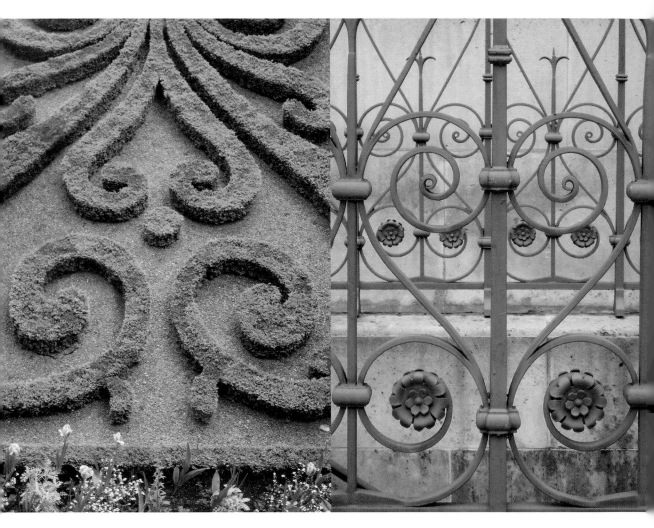

Parterre Garden, Musée Carnavalet

Louvre

Palmier | The palmier is made of hundreds of paper-thin layers of dough, prevented from sticking together by a heart-stopping amount of butter. The best ones are golden brown, caramelized, crackling, and flaky, and collapse in your mouth at first bite. Like other *viennoiseries*, they're meant to be eaten with tea or coffee, or as a companion to other desserts like ice cream or sorbet.

The making of puff pastry is an arduous task involving multiple and repeated "turns" of rolling and folding of dough and butter, with periods of rest between rounds of turns. According to some, the whole process can take up to six or seven hours and should produce 729 layers of butter between 730 layers of dough! It's not surprising, then, that the palmier originated at the beginning of the twentieth century as a way to use up the very last bits of this precious dough.

Palmier means "palm tree" and, turned with its curls upside down, the cookie resembles the fronds at the top of a palm tree. The distinctive curled-in/curled-out shape is a visual motif that shows up in many forms outside the kitchen — the box hedges of formal gardens, woven into tapestries and wallpapers, in decorative ironwork, and on mosaic floors. There's also the ubiquitous fleur-de-lis, the iconic symbol of the French monarchy: Reverse the outward curve of the leaves of the fleur-de-lis and *voilà!* the palmier.*

*

Madeleine | When Marcel Proust in *In Search of Lost Time* takes a bite of his madeleine soaked in tea after a dull and depressing day, it transforms his body and soul, and unlocks a flood of childhood memories.

"No sooner had the warm liquid, and the crumbs with it, touched on my palate than a shudder ran through my whole body and I stopped, intent upon the extraordinary changes that were taking place. An exquisite pleasure had invaded my senses.... at once the vicissitudes of life had become indifferent to me, its disasters innocuous, its brevity illusory..."

Thus is the power of a sublime dessert.

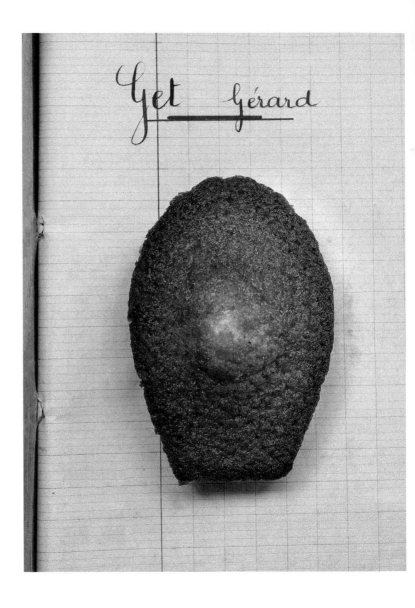

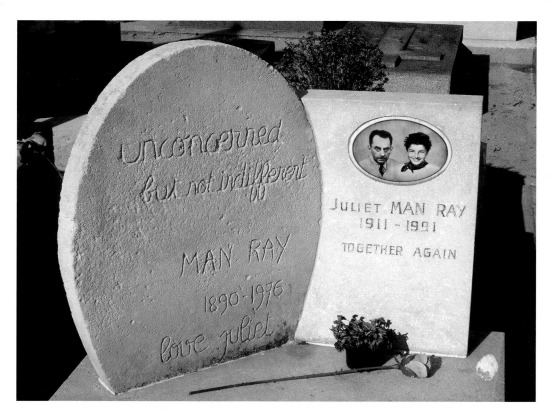

Man Ray's Grave, Montparnasse Cemetery
Man Ray is buried with Juliet Browner, the
last of his muses and lovers.

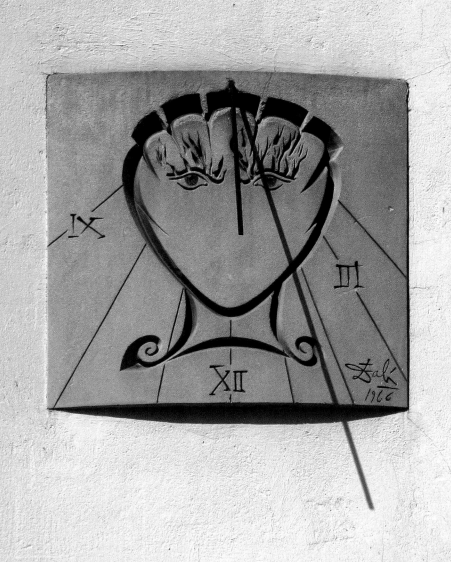

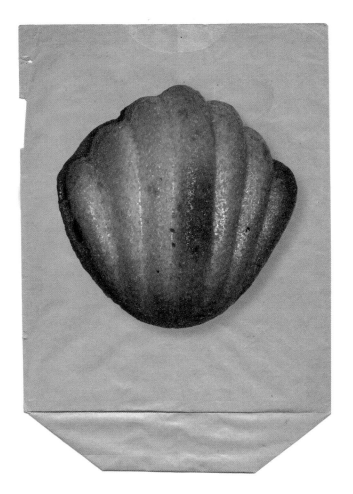

Madeleines are delicate sponge-like cakes flavored with lemon and baked in molds fashioned like a fluted scallop shell. Once again, there are conflicting stories of the origin of the madeleine offered by *Larousse Gastronomique*. One version is that it was the creation of Jean Avice, the nineteenth-century "master of choux pastry" who first baked them in aspic molds. Another account sets them in the French town of Commercy, which was then an eighteenth-century duchy under the rule of Stanislas Leszczynski, deposed King of Poland and father-in-law of Louis XV. Apparently Stanislas's pastry chef walked out in a huff one evening before dessert was prepared and a young servant girl named Madeleine stepped in with a recipe from her grandmother. Dinner was saved, and the King was so pleased that he named the cookie after the young girl.

Salvador Dali Sundial The sundial hangs just above a bagel shop on rue St. Jacques in the 5th arrondissement. The scallop shape (*coquille St. Jacques*) refers to the shrine of St. Jacques de Compostela and honors the pilgrims who walked along this street on their way to the shrine in northwestern Spain.

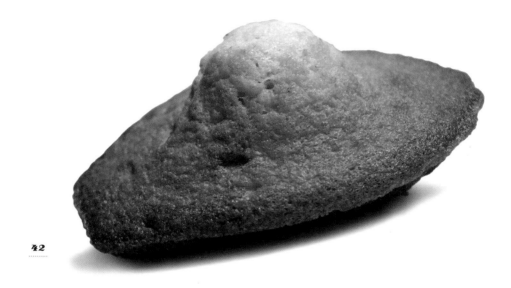

42

The bump on the back of the madeleine can be tricky to achieve (it involves a temperature shock when the cold madeleine mold* hits the oven). It's the treasured bit that French children bite off first. For a great selection of flavored madeleines with good-sized back bumps, try Fauchon on the Place de la Madeleine.

..
*

Financier | Another one of the great take-out snacks of Paris, the financier is a rich, moist tea-cake with a chewy outer crust, made with copious amounts of melted brown butter mixed with finely crushed almonds and egg whites. They were first made in the nineteenth century by a pastry chef in the financial district of Paris, near La Bourse du Commerce (the city's former stock exchange), and named for his banker clients who could afford them (the ingredients were pricey) and liked to eat them on the go. The classic ones are rectangular in shape, and are thought to have been designed to resemble gold ingots.* Today they're baked in a variety of shapes** and in flavors like pistachio or chocolate, and are sometimes embellished with bits of jam, a single raspberry, or a piping of ganache.***

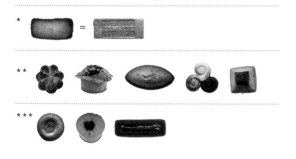

Pyramide du Louvre I.M. Pei's modern glass and metal pyramid in the classical Louvre courtyard was a shock to many Parisians when it was built in 1989. Detractors accused François Mitterrand of having a "Pharaonic complex"; supporters saw it as a successful merging of the old and the new.

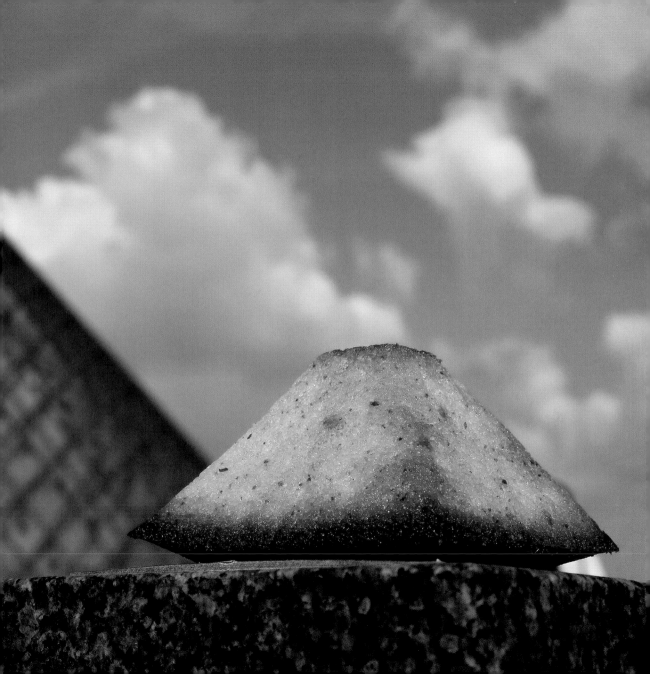

Canelé | There are countless reasons to love the French, but one of the most endearing is the seriousness with which they take their food. The story of the *canelé* is a tale of fierce protectionism bumping heads with the impulse to improvise, ending in a peaceful etymological compromise.

Long story short, a *canelé* is not a *cannelé*. The cake known as *canelé* (spelled with one "n") is the original, officially known as *canelé de Bordeaux*. It's shaped like a squat fluted column just a couple of inches high, with a thick, almost black, caramelized crust surrounding a custardy interior flavored with vanilla and rum. (Some people like the well-done ones, others prefer them lighter.)

Two different legends surround its origin: Prior to the French Revolution, a convent of nuns in Bordeaux created cakes called *canalize* using the egg yolks they received from a local winery, which used only the whites to clarify their wine. Another version of the tale is that the local Bordeaux dock-workers used flour that spilled off the load-ing docks to make cakes for poor children, and baked them in molds that were buried in hot embers.

Over the course of three hundred years, alternative versions of the original recipe sprung up. Flavorings like chocolate and orange were added, and this unregulated tinkering distressed the bakers of Bordeaux. In the 1980's an organization was formed to protect the original secret recipe, which is locked in a vault in the city of Bordeaux. The official ruling of the Brotherhood was as follows: Bake it by the book and you can spell it with one "n". All other versions must use two.

CHAPITRE I (¹)

LE PRINTEMPS

. triste hiver saison / mort est . temps du

sommeil ou plutôt torpeur nature . in-

sectes sans vie s mouvement . vé-

gétaux sans sans accroisse-

ment . hâ truits ou relé-

gués ceux qui nfermés dans /

prisons / glace . la plupart

/ animaux terrestres mestiques ou))

dans . cavernes . antres · terriers nous

présente · / l'univers . images lan-

gueur dépopulation Mais . retour / oiseaux

au printemps est . premier signal . douce

annonce du réveil nature vivante .

feuillages . . bocages revêtus / leur nou-

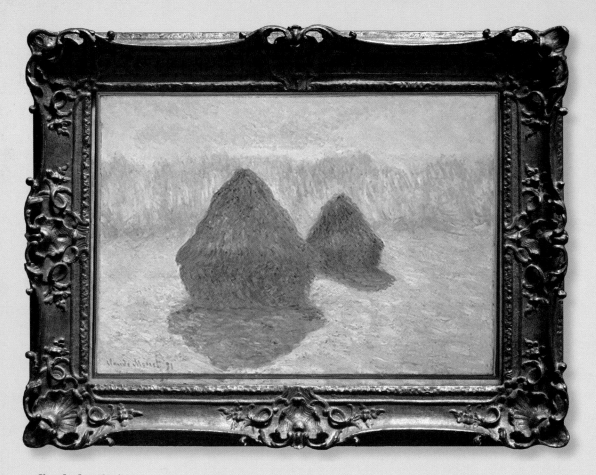

Haystacks, Claude Monet

Brioche | The famous quote generally (but falsely) attributed to Marie Antoinette, "Let them eat cake," was actually "Let them eat brioche." Despite the continuing controversy over who really said these words, they were the rallying cry against the French royalty and its obliviousness to the suffering of the peasants in a time of famine. In fact, French law obligated bakers to sell expensive breads like brioche at the same price as ordinary ones if the plain ones were sold out, so the remark may not have been as heartless as it sounds.

44

45

The rich, egg-y and buttery Normandy brioche has been around since 1404, according to food historians. The classic *brioche à tête* (brioche with a head) is baked in a fluted tin that narrows at the bottom, topped with a spherical piece of dough, and looks like it would make a fine hat.*

The tall, cylindrical *brioche mousseline* is made with double the usual amount of butter and is delicious with preserves, honey, chocolate — and more butter. Let it sit a day and it makes great French toast — known in France as *pain perdu* or "lost bread." Serving suggestion: Pretend you're at Ladurée and add a side order of whipped cream.

*

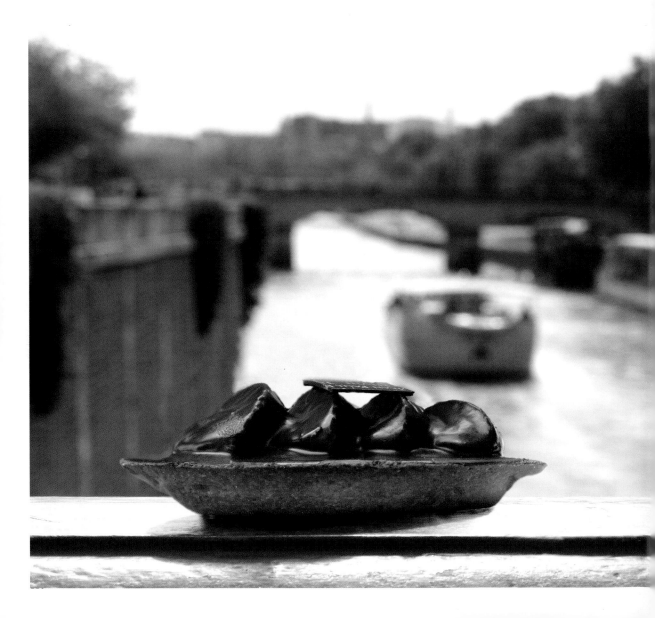

Barquette | Barquettes are *pâte sucrée* shells that can be filled with either sweet or savory ingredients. This one from Jean-Paul Hévin features almonds, chestnut cream mousse, and blackcurrants.

Pont de l'Archevêché connects the Left Bank with the Île de la Cité.

127

Tell me what you eat,
and I will tell you who you are.

Jean Anthelme Brillat-Savarin

Our Paris apartment was located at the corner of rue de l'Espérance (Hope Street) and rue de la Providence (Luck Street) in the 13th arrondissement. Most mornings at breakfast, I'd leaf through my pâtisserie bible (*The Pâtisseries of Paris*, by Jamie Cahill), choose a pâtisserie, and spend the day exploring the neighborhood around it. I'd buy a dessert, photograph it, and return to the apartment to cook dinner and share my findings with J. — a daily ritual of hunting, shooting, and eating.

The following list is by no means comprehensive. Be adventurous and try anything, anywhere you happen to wander. You can't really go wrong.

5
Angelina
226 rue de Rivoli — 75001

13 / 19
Arnaud Delmontel
39 rue des Martyrs — 75009
57 rue Damrémont — 75018
25 rue de Levis — 75017

15
Berko
23 rue Rambuteau — 75004

33
Blé Sucré
7 rue Antoine Vollon — 75012

30
Christian Constant
37 rue d'Assas — 75006

23
Délices de Manon
400 rue Saint-Honoré — 75001

45
Des Gateux et du Pain
63 bd Pasteur — 75015

4 / 18 / 42
Fauchon
24-26 Place de
la Madeleine — 75008

1 / 16 / 20 / 21 / 43
Gérard Mulot
76 rue de Seine — 75006
2 rue Lobineau — 75006
93 rue de la Glaciére — 75013

3 / 25
Gosselin
258 bd Saint-Germain — 75007
28 rue Caumartin — 75009

37
Hugo and Victor
40 bd Raspail — 75007

27 / 39 / 46
Jean-Paul Hévin
231 rue Saint-Honoré — 75001
3 rue Vavin — 75006
23 bis Avenue de
la Motte-Picquet — 75007

41
Boulangerie de l'Epi
41 rue Oberkampf — 75011

2
Ladurée
75 Avenue des
Champs-Elysées — 75008
13 rue Lincoln — 75008
16 rue Royale — 75008
21 rue Bonaparte — 75006
la Printemps at
64 bd Haussmann — 75009

10 / 11 / 17 / 32
Laurent Duchêne
2 rue Wurtz 75013

6
La Grande Epicerie at
Bon Marché
38 rue de Sèvres 75007

35
Le Loir dans
la Théière
3 rue de Rosiers 75004

22
Lenôtre
15 bd de Courcelles 75008
121 Avenue de Wagram 75017
48 Avenue Victor Hugo 75019
44 rue d'Auteuil 75016
102 Avenue du
President Kennedy 75016
36 Avenue de
la Motte-Piquet 75007
61 rue Lecourbe 75015
91 Avenue du
Général Leclerc 75014
110 Avenue de France 75013
22 Avenue de la Porte
de Vincennes 75012
10 rue Saint-Antoine 75004

34
Maison Kayser
Multiple locations

7
Pain de Sucre
14 rue Rambuteau 75003

28
Pâtisserie Blin
Philippe
202 rue de Tolbiac 75013

8 / 29 / 44
Pâtisserie des Rêves
93 rue du Bac 75007

26
Picard
Multiple locations

40
Pierre Hermé
72 rue Bonaparte 75006
185 rue de Vaugirard 75015
4 rue Cambon 75001
58 Avenue Paul Doumer 75016
Galeries Lafayette
40 bd Haussmann 75009

9 / 24 / 36
Plaza Athénée
25 Avenue Montaigne 75008

14
Rollet Pradier
6 rue de Bourgogne 75007
32 rue de Bourgogne 75007
200 bd Saint-Germain 75007

12 / 31 / 38
Sadaharu Aoki
25 rue Perignon 75015
35 rue de Vaugirard 75006
56 bd de Port Royal 75005
Galeries Lafayette
40 bd Haussmann 75009

About the Author

Susan Hochbaum is principal of Susan Hochbaum Design, a New York City graphic design firm. She has worked with museums, the fashion industry, educational institutions, and entertainment companies, and has designed and co-authored books on photography and visual culture. Her work has won numerous design awards and has been recognized in national and international design publications.

Prints of all photographs are available by writing to the author at www.susanhochbaum.com. Watch the trailer at www.susanhochbaum.com/pastryparis.html.

Acknowledgments

Special thanks to my publisher, Angela Hederman,
for her gentle guidance and her enduring exuberance.

I'm indebted to Flora Lazar for her generosity,
and to Christophe Michalak for offering his
brilliant creations.

Thanks to Clotilde Dusoulier for sharing her personal
stories and professional expertise.

And more thanks:

To my loving family and cherished friends
for their cheerleading

To the fates, for delivering big love

and, finally, eternally,

for envisioning Paris,
for splitting the calories,
for seeing the possibilities,
and for happiness.